RECEIVED SEP 3 0 1986

CCLOW/CCPEF
47 Main Street
Toronto, Ontario
M4E 2V6

FIRST CONTRACT
WOMEN AND THE FIGHT TO UNIONIZE

by CAROLE CONDE & KARL BEVERIDGE

© 1986 Between The Lines

Published by Between The Lines,
 229 College St.,
 Toronto, Ont. M5T 1R4

Cover and text designed by Carole Condé and Karl Beveridge, members of the
Independent Artists Union.

Typeset by Dumont Press Graphix, Kitchener, Ont.

Printed in Canada by Prolith incorporated.

Between The Lines is a joint project of Dumont Press Graphix, Kitchener, and the
Development Education Centre, Toronto. It receives financial assistance from the Ontario
Arts Council and the Canada Council.

Canadian Cataloguing in Publication Data

Condé Carole.
 First contract: women and the fight to unionize

ISBN 0-919946-70-4 (bound). — ISBN 0-919946-71-2 (pbk.)

I. Beveridge, Karl. II. Title.

PS8555.053F5 1986 C813'.54 C86-094220-1
PR9199.3.C66F5 1986

The Workers' Union of Dumont press graphix

GCIU GRAPHIC COMMUNICATIONS UNION LABEL INTERNATIONAL UNION

PROLITH inc.

CONTENTS

PREFACE

First Contract is about working women. The term "first contract" has come to symbolize the fight by women workers for union recognition, but that fight as a whole involves more than the right to unionize. It also includes a process of self-identification that goes beyond the workplace to the home, the family, and daily life.

Women, more than men, have been forced to confront the interconnection of work and life after work. To many women, the conditions of work and home are not that dissimilar. The move from a "man's castle" to a "man's world" is not necessarily a liberating one.

The fact that the women whose stories are told here must remain anonymous for fear of employer reprisals, is evidence of fierce resistance to the unionization of women. To these employers, union organizing means the loss of what is perceived as a cheap, obedient, and easily disposable workforce.

When we began this project we had no clear idea of what it was going to be about. It was the women themselves who shaped its content and direction. It is to these women that this book owes its deepest gratitude and thanks.

Originally we had intended to present photographs of the women themselves along with statements from their interviews. However, as their very real fears about being identified became apparent, we decided to fictionalize the material and use actresses. Despite a loss of documentary immediacy, the use of a fictional format allowed us to push the content much further, especially in developing a sense of personal experience. We would like to thank Gay Bell, who both directed and acted, Marilyn Crosby, and Sheila Miller for their sensitive and sympathetic portrayal of the women characters. They, along with the other actors, were both supportive and giving of their time.

To many this book may seem an oddity. It doesn't fit neatly into any one category. The book mixes art, labour, women's issues, and oral history, with the lines being blurred. In part this is an intentional crossing of barriers that increasingly separate and isolate us: art

for art's sake, business unionism, post-feminism, and so on. But it also indicates a variety of influences that have shaped our interests and work. Although there are many people to thank, the following have given special help: Ian Burn, Kamozi, Martha Rosler, Allan Sekula, Lisa Steele, Fred Lonidier, Csaba Polony, Clive Robertson, Susan Kennedy, Nancy Neamtam, and the late Kenneth Coutts-Smith.

First Contract was developed through the Canadian Educational Office of the United Steelworkers of America, and was first produced in 1981 as a set of photographic prints under the title "Standing Up". D'Arcy Martin, as Canadian Education Director of the Steelworkers, saw this project through from beginning to end. He not only introduced us to the union local where we met and interviewed the women, but also helped at every stage in the production of the book. We owe our greatest thanks to D'Arcy's trust of two artists, a respect for our autonomy, and his deeply held belief in the importance of cultural issues for the trade union movement. Without his support, this book, and the work it is based on, would never have seen the light of day.

We would also like to thank: Dinah Forbes, who originally encouraged and supported the publication of this book; Robert Clarke and Marg Anne Morrison of Between The Lines, who saw it through; Catherine McLeod, who edited a cumbersome text into its present, readable form and who provided the interview material that forms the basis of the last section, "Four Years Later"; Frances Lankin for her Foreword, which evokes the larger movement within which this all takes place, and who wrote it out of her commitment to that movement; Steve Izma, Moe Lyons, and the rest of the Dumont connection for their assistance in production; Jane Northey and Connie Eckhert of the Community Arts Committee of A Space who provided the opportunity to write the essay "On Art and Work"; David Smith and Linda Yantz for letting us adapt their listing of women's strikes, originally published in *Resources for Feminist Research* (Vol. 11, No. 2, OISE). The Explorations Program of the Canada Council provided funding for the original project, and the Visual Arts Office of the Canada Council assisted in the publication of the book.

We would also like to thank the many photographers and unions whose material was used in the photographs and in the appendix.

C.C. & K.B., Toronto, June 1986

FOREWORD

Frances Lankin

As we climbed aboard the yellow and black school bus we could feel the excitement. There was an electric charge in the air — the kind that occurs when you sense something important is happening.

A sister had handed out some printed song sheets and we broke into a rousing chorus of "Union Maid" as the bus lumbered out of the parking lot. Not all of us knew the words — in fact, not all of us knew the tune! But over the three-hour bus ride to our destination, we learned new songs, made new friends, and rekindled an old solidarity, once shared by our foremothers in their organizing around the turn-of-the-century textile workers' strikes.

We were on our way to a "Women's Solidarity Picket." It was 1979 and a group of ordinary (albeit incredible), women were waging a first contract strike against their small-town employer, Fleck Manufacturing.

Women had certainly been on strike before, and had certainly organized strike support before. But now the growing alliance between women's movement activists and trade union women activists was making an impression on the labour movement. In Ontario, the United Auto Workers and the rest of labour understood, perhaps for the first time, that Fleck was a "women's strike." They spoke about it as a "women's strike." They worked with women's organizations inside and outside of the labour movement to organize strike support.

The "Women's Solidarity Picket" was a first, a great success and an important development for working women and the trade union movement. We were to meet again and again — at Radio Shack, Irwin Toy, Fotomat, Blue Cross — on the line with striking federal government clerks, community college support staff, Mini Skools day-care workers, Metro Toronto library workers, Air Canada reservation clerks. We were to meet again and again in support of working women struggling for basic dignity and fairness — like the women at Block Drug Co., who were forced to punch a time-clock whenever they went to the washroom (their brother workers were not required to do the same) — or the women who worked at Pizza Crust and, with support, successfully fought their unjust dismissals.

The 1984-85 strike for a first contract by women workers at five locations of the T. Eaton Co. sparked the development of a women's "Strike Support Coalition." After the conclusion of the Eaton's strike, the coalition quickly re-formed when women workers at the Bank of Commerce Visa Centre launched their first contract strike with a daring sit-in reminiscent of much earlier struggles.

The links to the past are more than just a reliance on age-old strategies of confrontation. The nature of women's work and — more to the point — the nature of women's workplace struggles, bring us face to face with the very roots of our movement. The fight for dignity and fairness and for a decent living

ILGWU

and humane working conditions is characteristic of the earliest — and the most recent — trade union strikes.

A growing number of first contract strikes are "women's strikes" — quite a contrast to the fact that for years the organizing outreach of trade unions did not touch the majority of working women.

Women for the most part are clustered in a relatively small number of occupational groupings. Outside of the public sector, women work in job ghettos as clerks, secretaries, bank tellers, cashiers, sales clerks, waitresses, and hairdressers. These job ghettos remain predominantly unorganized. Many of them are found either in huge institutions such as the banks and insurance corporations that have the time, money, expertise, and definite interest in maintaining a union-free workplace, or in the thousands upon thousands of small offices and small businesses. In both cases, the difficulties of organizing, underlined by some notable attempts and failures, have kept the trade union movement at bay.

That is not to say that unions have been welcomed with open arms by the workers themselves either. Certainly another factor at play is the general antipathy most working women feel towards trade unions.

We all suffer from the mass media's biased portrayal of unions as a powerful but negative force in our society. Women, as a result of our socialization, are also taught to believe in a stereotypical female subservience and passivity in the face of power. It's natural then, that for most women, the initial thoughts of joining a union, of going out on strike, or possibly being involved in a major confrontation with their boss, seem alien and somehow simply wrong.

This hasn't been helped by the fact that the labour movement in the past has been as male-dominated and male-oriented as the rest of our society. The struggle of women within Canadian trade unions to gain a voice for issues of equality and to break down the barriers to our full and equal participation has in

IWA

many ways paralleled our workplace struggles. It has also been a major contributor to keeping the Canadian labour movement relevant, growing, and a strong force for social change.

Over recent years the labour movement has developed and fought legislative and bargaining campaigns for such issues as day care, equal pay for work of equal value, mandatory affirmative action, rights and benefits for part-time workers, paid parental leave, protection from sexual harassment, and protection from newly discovered health hazards such as emissions from video display terminals and photocopying equipment. The process had made many male unionists sensitive to aspects of female employment that they had never before understood. The greater understanding and sensitivity within the movement has made it more open and accessible to women.

And that's all to the good because now more than ever women and unions need each other. Women's jobs and our fight for equality are gravely threatened. The massive introduction into our workplaces of new technology such as word processors, automated teller systems, electronic information storage and retrieval systems, and a whole range of customer self-help sales applications, is doing away with enormous numbers of us in traditional women's jobs or forcing us into part-time employment. Layoffs, as a result of the economic recession, have wiped out most of us who had recently broken into "non-traditional" fields.

The conservative trend in government threatens to further dismantle our social service system. Women (whether elderly, poor, or single mothers), are not only the most reliant on these services, we are for the most part the workers who provide the services. In addition it is likely that the Canadian light manufacturing sectors, another major employer of women, will be virtually wiped out in the free trade war.

Employers will surely argue that in order to remain internationally competi-

tive they cannot afford to comply with proposed legislative interventions in the market system, such as equal pay for work of equal value or mandatory affirmative action. All this at a time when the new right, the so-called moral majority, the REAL* women, are fighting against measures for economic equality; are arguing for women's return to the home and family.

Yes, this is a time when women need unions. Those of us who are activists must continue to ensure that our movement remains a vital force in the struggle against our oppression.

This is also a time, however, when unions need women. The most recent recession took its toll on our unions and leaders. Massive layoffs and plant closures brought about a dramatic decline in membership numbers in the major industrial unions. Tough concession and take-away bargaining was the order of the day. The human tragedy of unemployment has touched the lives of millions of workers — if not themselves, then their neighbours or the friends who worked beside them yesterday.

As a result of these trends, the spirits of many workers are hurting. We have been bruised and battered. But not only does the labour movement understand that women's employment is an untapped oil well and if we are to continue to grow we must learn how to organize women's workplaces successfully; but we've also seen and felt the infusion of strength, of courage, and the steadfastness that women bring to unions. One has only to have spent some time walking the Eaton's picket line, or talking with the women from Irwin Toy, or watching the Fleck women standing fast against eighty police officers in full riot gear, to know what I'm talking about. The contribution that women have to make to trade unions is a revitalization of the movement.

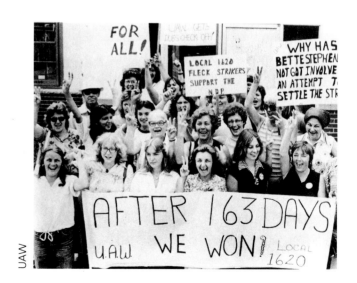

* Realistic Equal Active for Life, a specifically anti-feminist organization

This book is a celebration of that revitalization — a celebration of groups of women who against all the odds decide they want better, and decide to fight for it. It is a celebration of individuals, ordinary yet extraordinary; vulnerable yet strong; terrified yet fearless; oppressed yet free.

The images of ourselves are powerful and direct and not often seen. The following pages provide a rare glimpse into our lives.

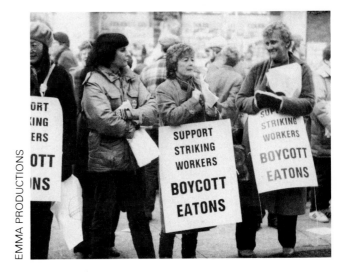

... As we leave the Women's Solidarity Picket, each of us feels a little stronger. In the giving of our support to our sisters we gain from their determination. It is the mid-1980s and a group of ordinary (albeit incredible), women are about to take an important step in all of our lives. The strains of Solidarity Forever linger strong within our hearts.

ON ART AND WORK

Carole Condé and Karl Beveridge

We are already five minutes late. The large, terraced government building in Toronto looks more like an oversized condominium development than an office building. But there it is, the reassuring half-maple-leaf of federal benevolence. People are streaming out. It is four-thirty in the afternoon, and life after work has begun.

Ted is waiting patiently when we arrive on the fifth floor. He must have known we'd get lost. His public service job is to process claims, but he is also recording secretary for the union local. We had talked to him earlier on the phone, arranging to meet with the local's executive after they get off work. We want to discuss the possibility of doing a project with the local.

Ted leads us past rows of small, empty cubicles, each with a tidy desk displaying folders, papers, and a photograph or two, presumably of friends or relations. We enter a large boardroom. Two tape recorders are noticeably present at one end of the boardroom table.

"Don't touch them," Ted warns, "or they'll give us hell." He introduces us to the other two local executive members, May and Dave, and explains that his bosses have made a special allowance for us to meet in this boardroom.

"You don't think those tape recorders are working, do you?" Carole asks,

hoping to break the ice after the introductions. But Ted answers seriously, quietly, "You never can tell." He looks at the machines with unexpected suspicion. "I wouldn't put it past them."

We begin talking and, as we usually do when we first meet with people, we start by giving our own backgrounds. After all, it must be kind of strange; one day a couple of artists walk in and say they're interested in doing an artwork with the local. So we tell them, in not so many words, how we started out as sincere but naive modernists, and how we became disillusioned with what we see as the competitively self-destructive artscene. How the art market perverts and devalues creativity. How and why such art is elitist, inward-looking, and cynical. How we became interested in working with different communities and approached trade unions. We tell them about other artists we know who work with unions, and about the labour/arts committee of the Labour Council of Metro Toronto.

It is difficult to explain all this in ten hours, let alone ten minutes. The unionists ask some questions and we try to explain it a little better. We also tell them we're not working for the union's national office, or the NDP, or — god forbid — management. We did get an arts grant from the Canada Council to do an "artwork."

They're understandably puzzled when this word "artwork" comes up. We tell them that for us this means art about the lives of working people — the immediate life, the jobs, the experience, the good things and the bad. "How you yourselves see things," we say. "Most of the stuff you see on TV, for example, is about the problems of the rich, cops, doctors, or movie stars. . . ."

"The glamorous life," Ted cuts in. "That's one thing this place isn't."

"Right," Karl continues. "How often do you see something about the jobs most of us do? Unions, forget it — if they're mentioned at all, it's negative."

"I know what you're saying, but it sounds like rhetoric." Dave speaks up for

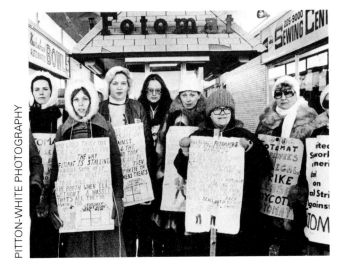

PITTON-WHITE PHOTOGRAPHY

the first time. He's a shop steward, younger than the others, and has been keeping a distance from the conversation. "I think what Ted's trying to ask, what worries him, is what's your slant on all this? What preconceptions are you bringing to this?"

When it comes to preconceptions, we have plenty — as do the people we work with. What is really being asked is what side you're on. You've got to be seen as a trade unionist. Art is what you do for a living. One time we were doing a project with the Autoworkers, at a time when Auto was big in the news because negotiations were coming up. At a dinner for Auto retirees, a journalist from a sophisticated, nationally distributed magazine turned up, spotting a chance to get a good story. He went around the dining area interviewing many of the same people we'd been talking to for our project. After a while some of the retirees came over to us and said they were really glad we were working with them, they felt uncomfortable with this magazine fellow, didn't feel good about the way he was asking questions. They had a sense of being used. It seems journalistic "objectivity" doesn't wash when you're dealing with the complexities of people's lives, when people's livelihoods and everything that means — social, economic, mental well-being — are at stake.

We're always being asked, too, how artists can expect to portray the experience of workers. Because we are artists, working on our own initiative, with all that aura of personal creativity and freedom, we don't experience "alienated labour," critics and some of our peers in the arts community say.

It is true that as artists we have some control over what we do, that we get a lot of satisfaction out of the "creative" aspects of our work, and that arts management keeps a polite distance: arm's length, so to speak. Our work isn't supervised, we don't have someone looking over our shoulders. But all this

ANON.

doesn't mean art is something special. It is just different. We don't have the corner on creativity.

A few years ago we were doing a project with women who were organizing a union. We had these vague notions about involving them in the actual production of the work until one of them pointed out: "Look, we're skilled in what we do. We know what we're dealing with. You're skilled in what you do. I wouldn't know one end of a camera from the other and I don't particularly want to. As long as you do a good job, we'll do our part."

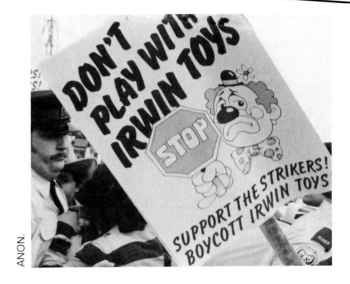

ANON.

It wasn't that they weren't interested, particularly in the use of media, which they understood. It was that their time was taken up with the union, their job, and family. Workers might think we're a little strange at times, but what mystifies them the most is that we work for next to nothing. That's weird to them.

Another aspect of this is that our product — artwork — is more often than not considered socially frivolous and useless, a "frill" in society's scheme of things, traditionally a hobby of the rich. From this point of view, it is intensely alienated.

Secondly, the majority of artists — ourselves included — live on the margins, if not in the mire, of poverty. The "struggling artist" is not wholly a myth. A few strike it rich eventually, but for most it is always touch and go. Then again, for many, striking it rich is not the goal.

Perhaps even more important, we feel ourselves part of the same social movement as trade unionists; we're fighting for the same things: fair wages, better quality and conditions of work, some control over our social and economic future.

And finally, the union movement is the social basis on which we can meet people, have a common point of reference, and, most importantly, a common trust. There are, of course, other organizations you could work through: churches, community centres, political organizations, various social move-

ments, and so on. Any of them could work. The main thing is that you identify with them, share the same goals — or you can forget about the trust. It's important that you feel a part of whatever organization or group it is.

Our interest in unions goes well beyond subject-matter. It has very much to do with our own lives, our problems, our future. So we've decided that our art and our work will be a kind of labour art, a community-based artwork. This means partly that we're not just responsible to ourselves for the art we produce, that we don't just work to produce art as individuals with our own particular burning visions, but that we make ourselves responsible to the community — in this case the community is the union movement.

Here we're getting into the politics of art production. The production of art as a service rather than as a means of supplying commodities for a market. A public service. Art as the articulation of a collective self-identity, not the production of "priceless" (but, really, "pricy") items for the wealthier among us.

In part, the development of community arts in Canada has been overshadowed by the rhetoric of national identity. In our preoccupation with establishing an internationally marketable culture, artists search for the illusive entrepreneurial heroes (and the odd heroine) of national expansion, rather than those "ordinary" lives which, if present at all, are generally just the backdrop for such myths.

In a speech given at a forum on community arts a few years ago, the then head of the Canada Council, Timothy Porteus, friend of Pierre Trudeau, stated that social communities and, therefore, the basis for community arts simply did not exist in Canada. He went on to add that the only culture in Canada was the one that had been carefully nurtured by none other than the Canada Council — as revealing a statement as it was arrogant.

In fact, the advertising budget of General Motors of Canada is roughly equal to the budget of the Canada Council. As consumers we pay for GM's advertising: That's corporate culture. Democracy in action.

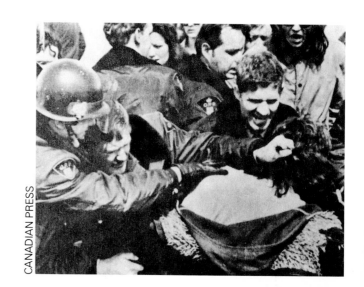

CANADIAN PRESS

And speaking about democracy, community arts is the means whereby the democratization of culture is practised. In Australia, the labour movement, other communities of interest, and community organizations have successfully pressured the Australian (arts) Council into establishing community and labour/arts programming to the tune of $3 million to $4 million a year. Not only that, but they are starting to disperse funds directly to some of those organizations.

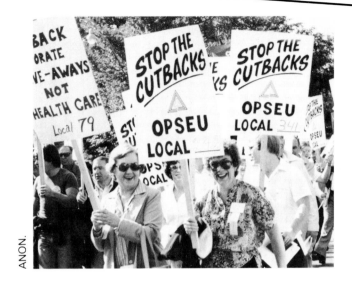

ANON.

At one point in our conversation with the Toronto public service local, May asks what an arts grant is. May is president of the local.

"You see, we get these arbitrarily-awarded three-month to one year non-renewable contracts with no guarantees or benefits, $1,000 to $1,500 a month maximum after twenty years' service. No pensions, UIC, workers' comp, no nothing," we reply. A chuckle of recognition crosses the room.

After we got this particular Canada Council grant, we had begun the work by phoning up a number of union contacts. This stage is important: you have to find a trade union staffer who's going to support you and clear the way. In this case it took a couple of months to clear the way. Calls from head office in Ottawa:

"What's the work being used for?" "Who's paying for it?"

Money is very important. It's usually the first question asked. You see, despite the rumours, unions don't have a lot of money to throw around and they have to account to their membership. Can you imagine a union staffer explaining to the membership: "Well, we went and spent $10,000 on this artwork. . . ."

"Artwork — bloody hell! I'm getting screwed out of workers' comp, and they buy an artwork."

After phoning our union contacts we arrange a meeting with the staff reps of a public sector union. The meeting lasts three hours. Our proposal is taken

seriously, no apologizing for what we do. We discuss possible themes, which locals would be responsive and interested, what we have to do to get started. We go on to talk about labour/arts. Two of the reps are interested in joining the arts and media committee of the Labour Council. Great.

The staff reps of the public sector union contact a couple of locals. Would they be interested in our project? The locals meet. They discuss it, back and forth. Finally we get a call. We're to meet with the executive of a local. We have to see if we're right for each other. That's when we get to the meeting with Ted, May, and Dave.

Our preconceptions? "Well, to a large degree it's up to you. I mean, what we choose to deal with depends on what you consider to be important. Obviously it'll be pro-union," we begin. A bit vague, but true.

"There's a lot of people here who aren't pro-union, you know," May says. "We were legislated into unions. So there's a lot of apathy. Do you include that?"

"Yes, if you feel it's important to look into. It could be quite interesting," Carole ventures. You're not always sure about what's being asked.

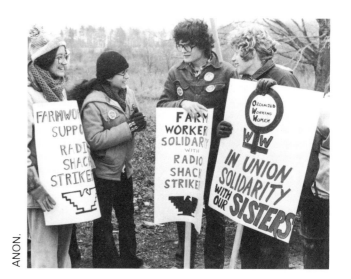

ANON.

"People here are frightened. They're not sure about their future," Dave says. "Didn't use to be like that. This department could be closed down. They're already contracting out stuff."

"That would be important to cover," Karl says. A meeting like this, we find, is a process of negotiation. At this stage we're just sounding ideas. You keep your ears open. Carole says, "Perhaps we should explain how we go about our work. . . . We usually start by talking with you people like this. Get a general picture. What people are concerned about, that sort of thing. Then we interview members, a cross section, women, older and younger workers, minority workers, people in different job areas. From this we develop a story."

"We fictionalize all the material so that no one's up for grabs," Karl adds.

"No one would be able to say so and so said the manager's an idiot. From there we develop the visual concepts and hire actors for the photographs."

"Through this process we'd like to show those involved the concepts as they develop," Carole says. "So what do you think? Are you interested?"

"Sounds okay," May says.

"I don't have any problems," Dave says. "I think it's a good thing to try to do, and it may as well be with us."

"I have one last question," May says. "Why do you want to work with unions? When you get right down to it, what have unions got to do with art?"

Oh boy — our favourite question. Once again, how do we answer that one, in brief? Why unions? What have they got to do with art? They can help to reclaim it, to create a living culture that affirms life and labour. And to hell with the cynics.

"Let's put it this way," Carole responds. "It's because of the union movement that we're sitting here and talking. How else would we have met?

"You see, we believe art should be about how we see things, our fears and hopes."

"We also believe," Karl adds, "that all of us should be able to say and show what our culture is and what it should be. And unions are one way we can begin to do this collectively."

"That's all pretty idealistic, isn't it?" Ted says with a somewhat patient, supportive kind of a smile.

"But," May counters, "Ted also said we'd never get the membership out when we had the last strike. Christ, we not only got them out — we had a hell of a time getting them to go back after we settled. It goes to show. . . ."

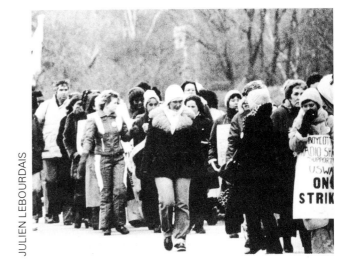

JULIEN LEBOURDAIS

STANDING UP

What follows is a true story. It is based on interviews with several Canadian working women the year after they formed their union and were forced to strike for a first contract.

Although we have fictionalized the characters and specific references in the story, the events are real and unfortunately typical of a number of recent strikes in the province of Ontario.

Fleck Manufacturing, Radio Shack, Blue Cross, Fotomat, Irwin Toy, Eaton's, and the Bank of Commerce have much in common. They like to hire women and they strongly resist the right of women to bargain collectively.

PHOTOGRAPHY
CAROLE CONDE AND KARL BEVERIDGE

WITH THE PRODUCTION ASSISTANCE OF
GAY BELL

ACTING
Gay Bell, Astra Crosby, Marilyn Crosby,
Simon Wohl, Sheila Miller, Jennifer Shultz,
Candice Doff, Simara Beveridge, Robert Reid,
Lisa Steele, Kenneth Coutts-Smith,
Heather Allin, Randy Parker

Glossary

- *Bargaining-in-bad-faith:* a term used to define a situation in which a company negotiates with no intention of reaching a settlement. In cases where a first contract is being negotiated, a company may stall the negotiations for a year, at which time it can apply to have the union de-certified.
- *Collective Bargaining:* method of determining wages, hours, and other conditions of employment through direct negotiations between the union and employer, which usually results in a written contract.
- *De-certification:* a vote taken by employees to get rid of a union. In most instances it is company inspired and used when a company refuses to negotiate.
- *First Contract:* when a new union local is formed and certified, it has to negotiate a contract within a year in order to retain representation of the employees concerned.
- *Grievance:* complaint against management by one or more employees, or a union, concerning an alleged breach of the collective agreement, or an alleged injustice.
- *Labour Relations Board:* a board established under provincial or federal labour relations legislation to administer labour law, including certification of unions, investigation of unfair labour practices, etc.

NATALIA

When Ed, Natalia's husband, found a job at a local automotive parts plant, Natalia packed in her job at a Toronto food processing plant and moved with him to this middle-sized city. They live in a small bungalow just outside town with their three children: Amy, fifteen, Jerry, eight, and Kim, six.

Natalia has worked for the company now for seven years, longer than any of her co-workers. She has done many different jobs over the years, most recently categorized as an "order picker." Earlier, she had been promoted to "lead hand" — a promotion she lost when she decided to defend two women threatened with lay-off. When she and others organized a union local and later went on strike to win a first contract, things got worse — until finally the company was charged with bargaining in bad faith.

Since the beginning of all this Natalia has been a source of embarrassment to the company managers, who like to claim that strikers like her are either outside agitators or misfits. Natalia is neither.

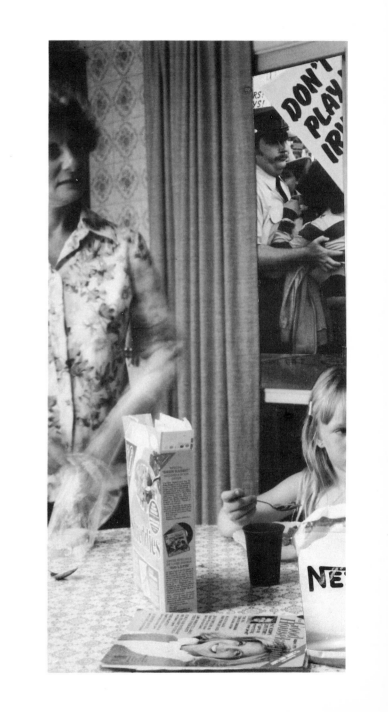

My god, but it's peaceful early in the morning. You know, the girls at work laugh when they find out I get up at 4:30 to clean my house. They tease me, they say I'm nuts. Well, when else do you get the time? And the garden — when was the last garden we had? Three years ago?

There's just no time for gardening when you're working. There's no time for anything. My youngest, Kim, hasn't been herself lately. She locked herself in her room yesterday. I haven't been myself either. How was I to know the damn inventory was going to keep me late at work? I had to count three hundred 10723s and I don't even know what they are. And the company won't tell you. If you know too much they think you're a threat.

How can I explain these things to Kim? All she knows is I got home late and we didn't get to go shopping together, like we planned.

Then I catch her sneaking the dessert and I blow up. It's terrible. We work our butts off for our kids, then we've got no time left for them.

And can Kim understand when I tell her that it was worse before we got our union? At 11:30 at night they'd call you and announce you were on days tomorrow. You'd get off at 12:30 and have to be back at 7:30 the same morning. I'd tell the foreman I needed a babysitter and he'd say "no babysitter, no job." He'd say I could suit myself. Just like that.

I wish Kim could understand how hard it's been, trying to love her, keep the house nice, and work at the same time. I don't even have time for my garden.

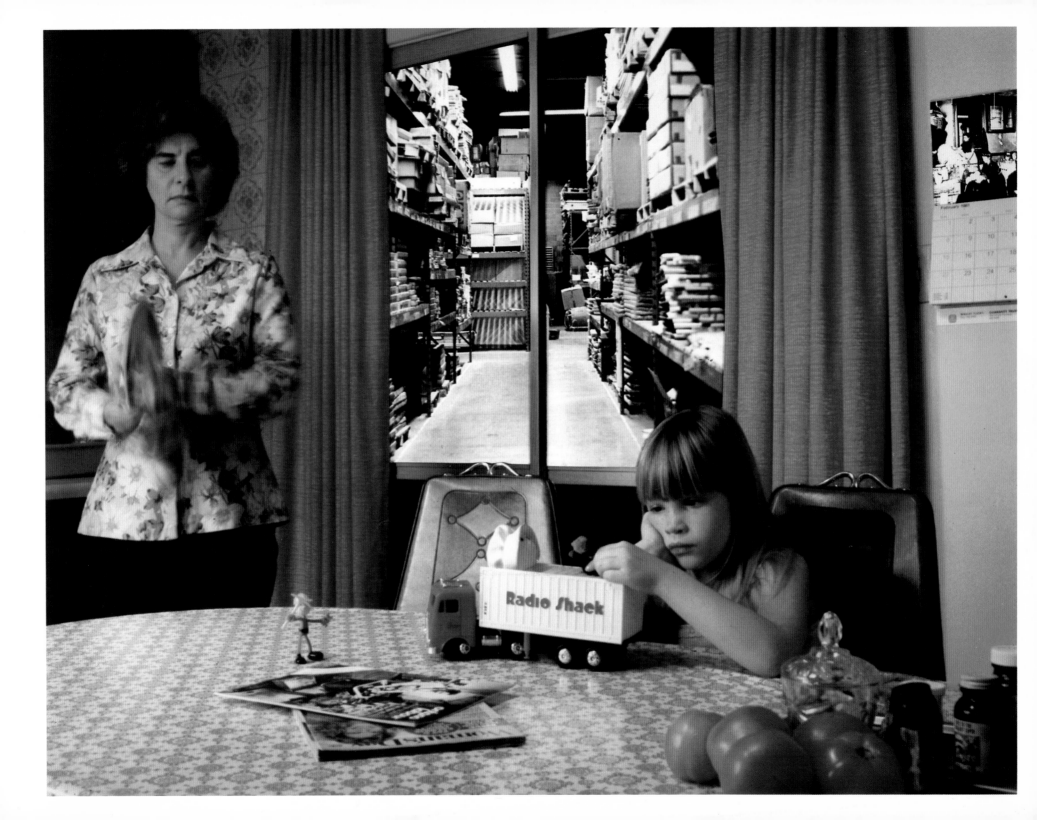

I remember the day we started thinking union. It was crazy Marg who finally grabbed a phone book out of the warehouse.

"I just can't stand it anymore," she said. "We've got to do something. How do you find a union? There's gotta be a union." None of us knew.

"How do you ask for a union?"

Desperate wasn't the word for it. We were caught in a revolving door. Job one day, out the next. Living in fear.

I don't remember now who first got ahold of the union. Probably Ray. All I know is, soon as I heard there was going to be a union meeting, I knew I'd sign up.

It was unbelievable. The company went nuts. And it never let up. We lost forty-five signed-up people the first year before the strike. Think about that. Imagine what that was like for us. Forty-five casualties. If we'd had those people when we finally went out. . . .Well, that's another story.

We were out on strike for nine months. Three seasons of our lives. And we never knew what was going to happen next.

You know, there's not much traffic on country roads like ours. One night during the strike I looked out the window and saw the same big, black car that had been outside the union hall. It passed our house twice. I told the kids to get inside. When they asked me why, I shouted, "Just get inside." We were terrified — for three whole seasons of our lives.

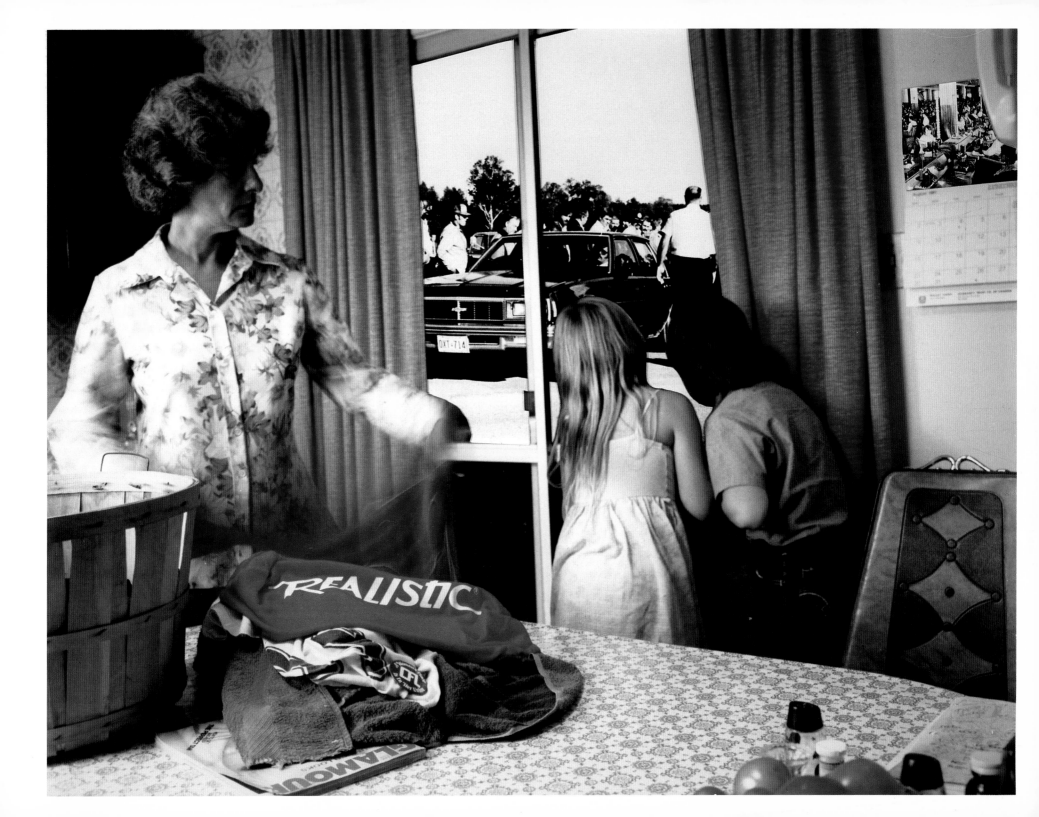

Jerry took his books to school in our boycott bag. My kids didn't know the issues, but they knew it was important to me. And if any kid at school knocked our strike, there'd be a fight. A lot of fights took place. It was hard on the kids. What did they know about the real fight? The fight between the parents.

See, for the kids, their fight was just as big and just as hard. And so unnecessary.

And it's not like it was discussed openly in the school. They had this Show and Tell one day. The son of one of the managers got up and told his father's side of the story. His dad was a big muck-muck in the company. Then my Jerry got up and explained that his mother — capital "M" MOTHER — was a big muck-muck on the picket line.

And what does the teacher do? Closes down the discussion.

Now, I ask you, what did that do for either of those kids? What good did that do for any of the kids in that classroom? It taught them to fear each other. And it taught them to shut up about the things they need to say.

So, they end up saying it on plastic boycott bags. I'm not trying to knock the school system or anything like that, but surely we could do better than that.

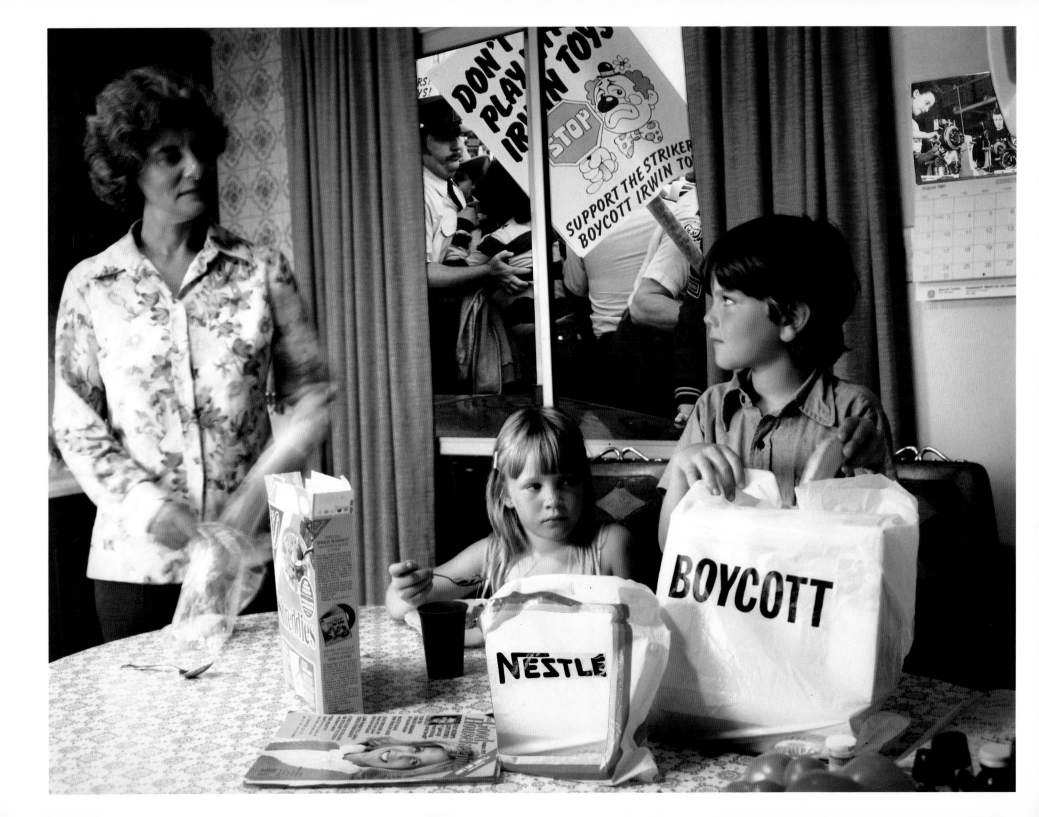

Like I said, the company went nuts. They tried everything to avoid reaching an agreement. We kept hoping. Trying this and trying that to reach a just settlement. But the strike dragged on and on.

And they knew who we were. Photographed us all the time. They even had video cameras on us. They knew how we moved, they knew what we said. They knew who we were. They even knew what our dreams were. They read our signs and studied our offers. We were fair. And they still fought us.

The cops were always around. It was shocking, my god, to see them. So many of them — in uniforms. Big guys, carrying guns.

I counted a hundred and two cops one day. We'd had a good turnout on the picket line and we'd been feeling good, 'til I noticed the cops. Then I got nervous. I even saw a dog in one of the cruisers. A dog — would they turn dogs on a group of factory women wanting to earn a decent living?

If you tried to walk in front of a scab's car you'd get an expert elbow in the throat.

I'll tell you one thing. Before I went out on that picket line I trusted the police department. If they came to the door and said my kid had gotten into trouble, I would have believed them. My own kid would have had to prove her innocence to me. That's how I was taught to respect the law. That was before the strike.

I discovered on a picket line that cops can lie through their teeth. Do anything to get a conviction. I guess I thought they were above stuff like that. Probably some of them are, but not the ones I met on the line.

Then there was the phone. We'd get threatening calls, like "tonight you die." And these weren't just kids calling up.

One night Amy was home alone and she started getting calls. She was so scared she had to run over to her friend's house. Why should a fourteen-year-old child have to learn about things like that? Is that the kind of world I want for her?

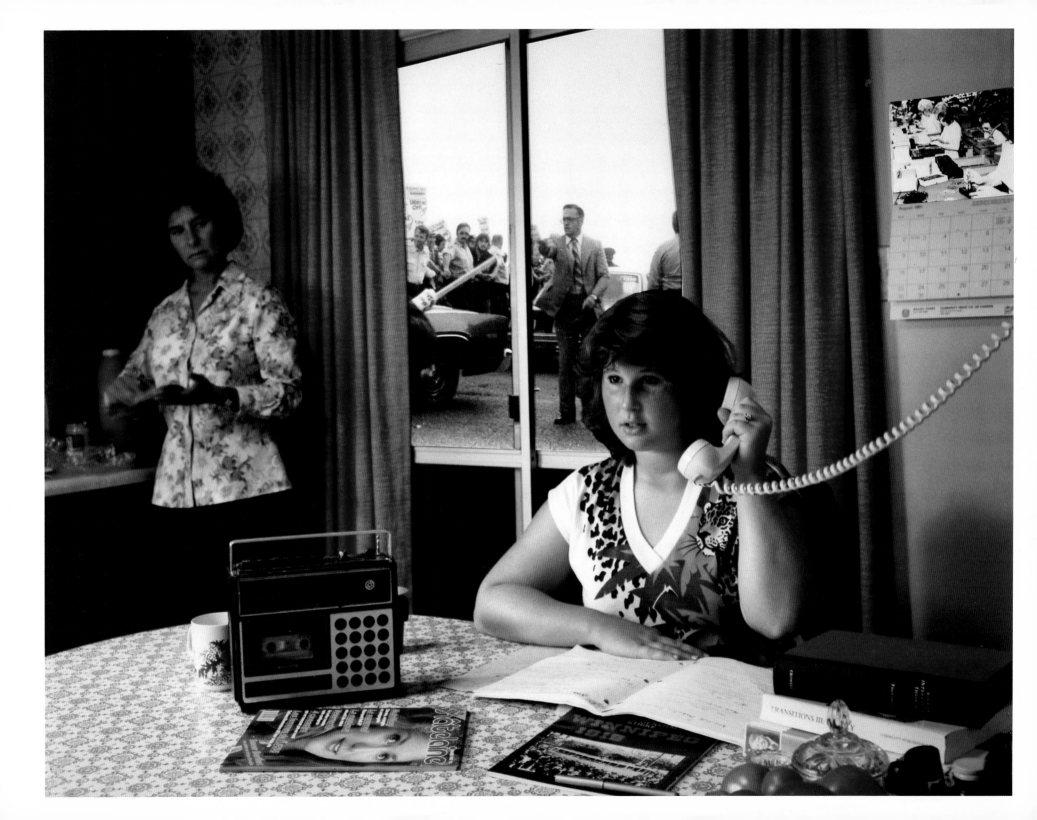

When we had to go to court — the company had appealed the bargaining-in-bad-faith decision right to the top — we thought we were in the wrong place, it felt so much like a church. It was hard for us, we didn't know what was going on.

Our lawyer, I'll never forget, would only say it could be bad and it could be good for us. He didn't know, either. Then the judge comes back and says something like "dismissed for reasonable cause." We all just sit there. What does it mean?

So we follow the lawyer out of the courtroom and we ask him. He reaches out and hugs me, and then I know. He says, "We won. We won the whole damn thing." Nine months, and we finally win in this strange courtroom.

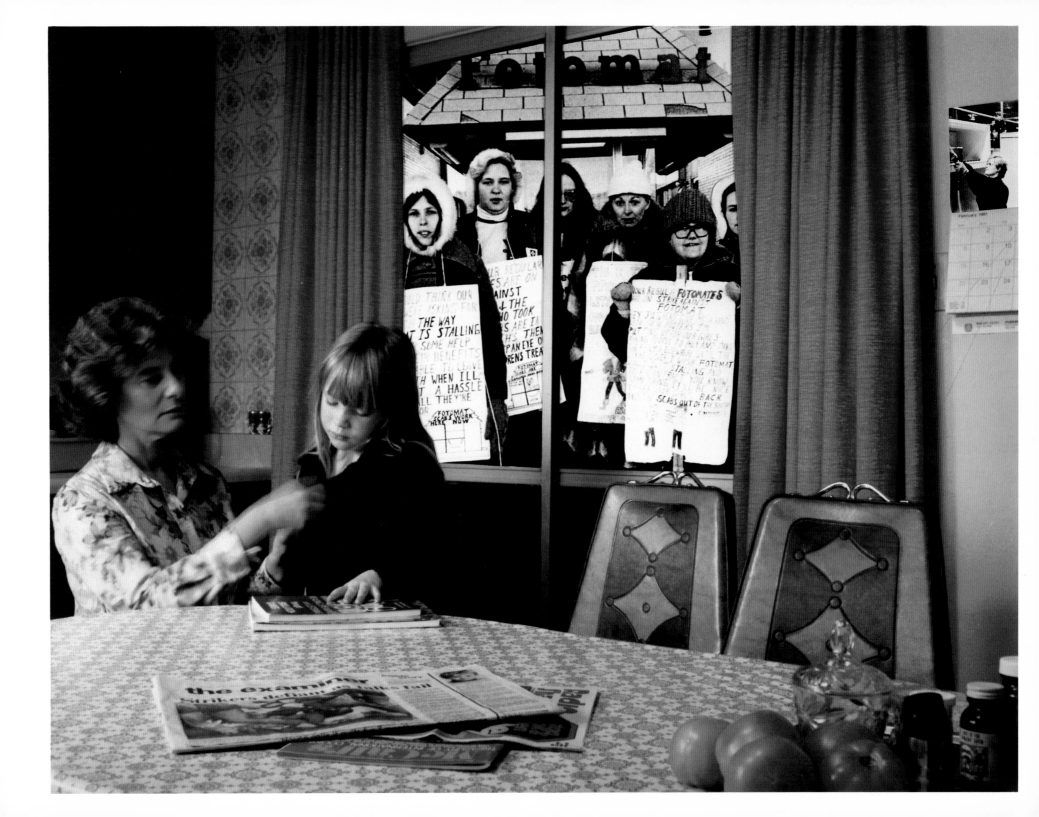

LINDA

For Linda, the worst thing about the strike was the damage it did to her family.

She had a brother-in-law and cousin crossing the picket line — her picket line. She worked in the warehouse, they were in management. She had a husband out of work, and a father who had just lost his farm. Family gatherings, so important to Linda, started to feel like a battle zone.

Her brother-in-law was a foreman. Her cousin had told her about the job in the first place, four years ago.

She'd find herself at her parents' place, looking at people she'd loved all her life and wondering how they could be so blind to the harm the company was doing to them and their community. No painstaking explanations or tears could break the deadlock around the family table. No one could answer her questions.

Early in the evening she'd find herself balancing the salt-shaker on its end and watching the clock, wishing she could leave. There were no more songs, no good jokes. Things were disappearing, just like the family farm south of town. That was because of interest rates.

Then there was her husband Jim. Nothing they had dreamed about had turned out. They had married when they were young, and for the first few years she had worked part-time as a waitress, hoping for something better. Then she got a job as a stock handler. Jim wanted to start a business, be his own boss. But it didn't work out that way.

Jim was looking for a job the whole time Linda was out on strike, and Linda was desperately looking for answers.

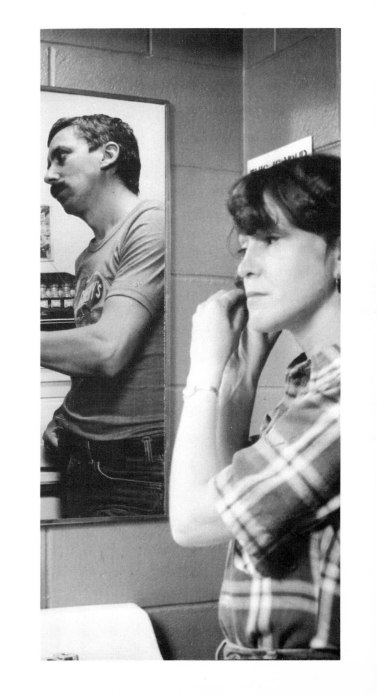

"You're mouthy. You've changed." That's what Jim said to me this morning. Married six years and we're always at each other. Always arguing.

I get a fifteen-minute break and I waste it in the washroom, smoking cigarettes and arguing with Jim in my head. It wasn't supposed to be like this.

But I think he has a point, even if he is blunt. He reminds me that I'm at home now, not on a picket line. He doesn't think I need him anymore. No wonder he's mad.

It's hard to explain what it's like to him. If he worked with me, it might be different. Then he'd understand.

I can talk to the women at work, anyway. Since the union, I don't feel completely alone. I don't feel so crazy.

Before the union, you had to keep your mouth shut. There were two hundred people in the warehouse and nobody talked. We didn't even know what anybody was being paid.

One girl got a thirty-cent raise. Another got ten cents. And it had nothing to do with how long you'd worked there. I got fourteen cents. Keep your mouth shut, and don't ask any questions. For fourteen cents.

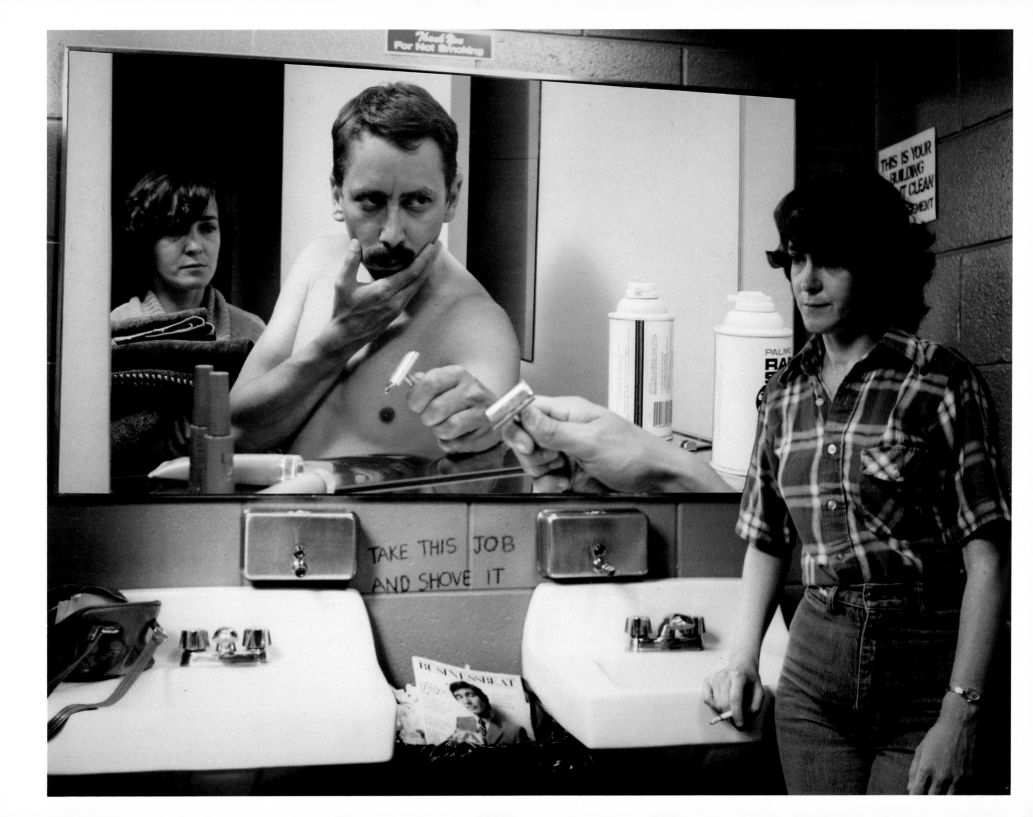

Jim blew up when I told him I'd joined the union. He said I'd lose my job. Then where would we be? I was scared. You gotta remember, I didn't know anything, absolutely nothing about unions.

The first I heard about the union was the night Vicky and Jo called my cousin and me over to their car. We were on our way home from work. We got in the back seat and they both turned to us and asked what we thought about getting a union into the warehouse.

I was shocked at first. I thought that unions and strikes were the same thing. Like a lot do, I suppose. I was afraid we'd lose our jobs.

But I found the guts to sign. I guess I figured I could lose my job anyway, the way things were going. Honestly, I felt I had nothing to lose.

Jim was out looking for work but there wasn't much around town. So he got depressed, thought it looked bad to have me supporting him.

Well, we finally got the union. But the company wanted all sorts of things in the contract that we found offensive. You could be fired for immoral behaviour. What did that mean? Transferred with no consideration of how long you'd worked there. Things like that. Well, no way — we couldn't take that. Out we went.

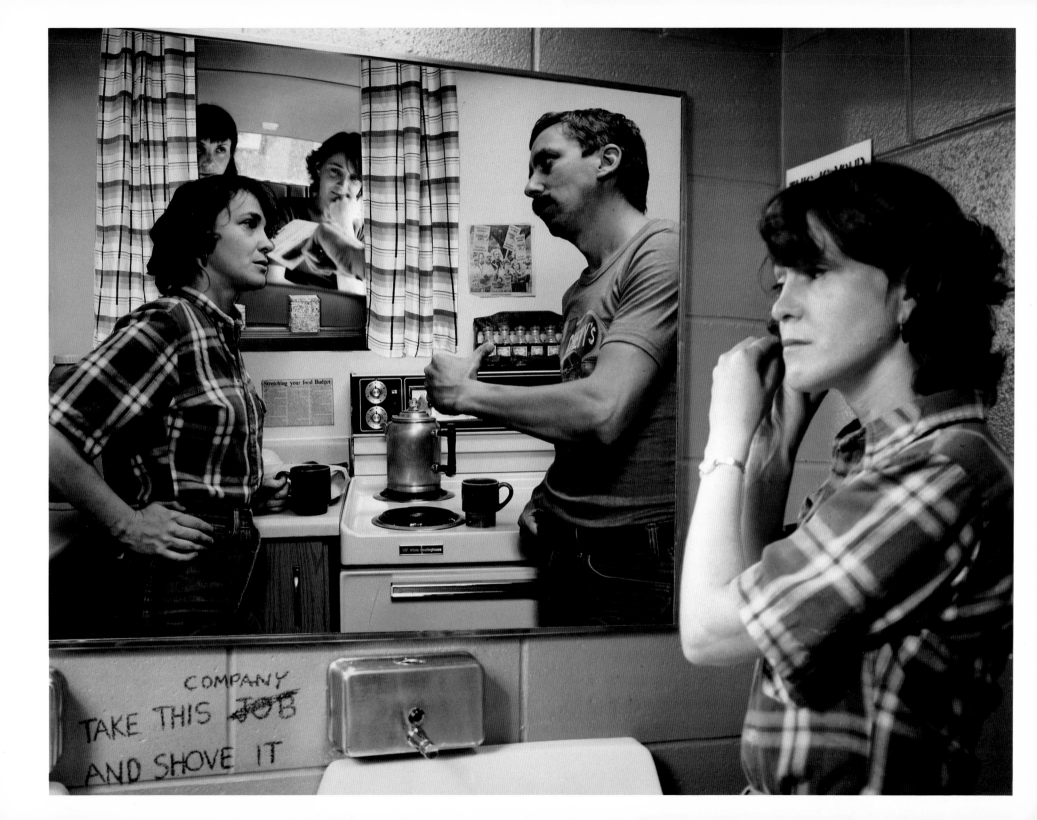

We knew we had to walk in front of those cars crossing the line. We didn't stop many — the cops were everywhere — but we sure slowed the cars down.

A lot of those people coming through our line were afraid or ashamed. Some were angry and would yell at us. Others actually hid. I saw six men huddled on the floor inside one van.

One day Jo was hit by a pick-up. Thank God she wasn't hurt. The cops didn't do a thing about it, though, nothing at all. It just wasn't fair. Scabs could hit you with a car, push you around. But if you defended yourself, by God, the cops were right on top of you.

I kept telling Jim we were standing up for our rights. I kept telling him I wasn't against him, that I loved him. But he wanted me the way I used to be. You know, when we were first married we had such big plans. A picket line wasn't part of them. And we were still in the same little apartment.

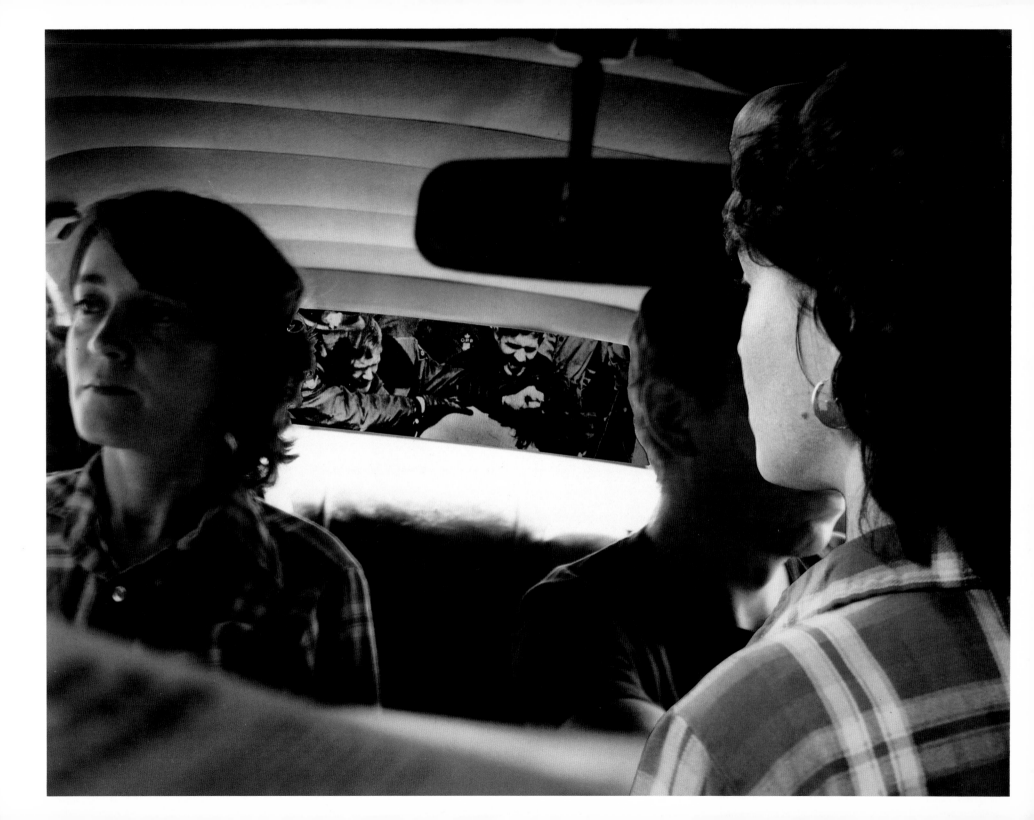

A lot of people said our strike was violent. One time a salesgirl asked me if I was on that "awful, violent" strike. I told her I must have missed all the excitement, because most of the time we crocheted, read books, and just passed the time of day. There were seven or eight days we had a lot of support on our line from other unions and women's groups from around the province, but besides that, our strike was quiet.

The TV just said things like, "This is the ninth week of the strike. There was violence on the picket line. Fifteen cars were damaged." They never mentioned how many of us were hurt — more interested in damage to cars. Never mentioned how our whole community was hurting. The real damage.

We used to go up to the mall and hand out our boycott bags, buttons, and information sheets. It was great to hear total strangers encourage us to keep standing up to the company. The company hurt its reputation by treating us the way it did. All across the country.

My brother called me all the way from Oromocto, New Brunswick, to tell me our boycott had succeeded in closing down the local company store. Oromocto: I had to look it up on the map. Our voices were being heard all over the country.

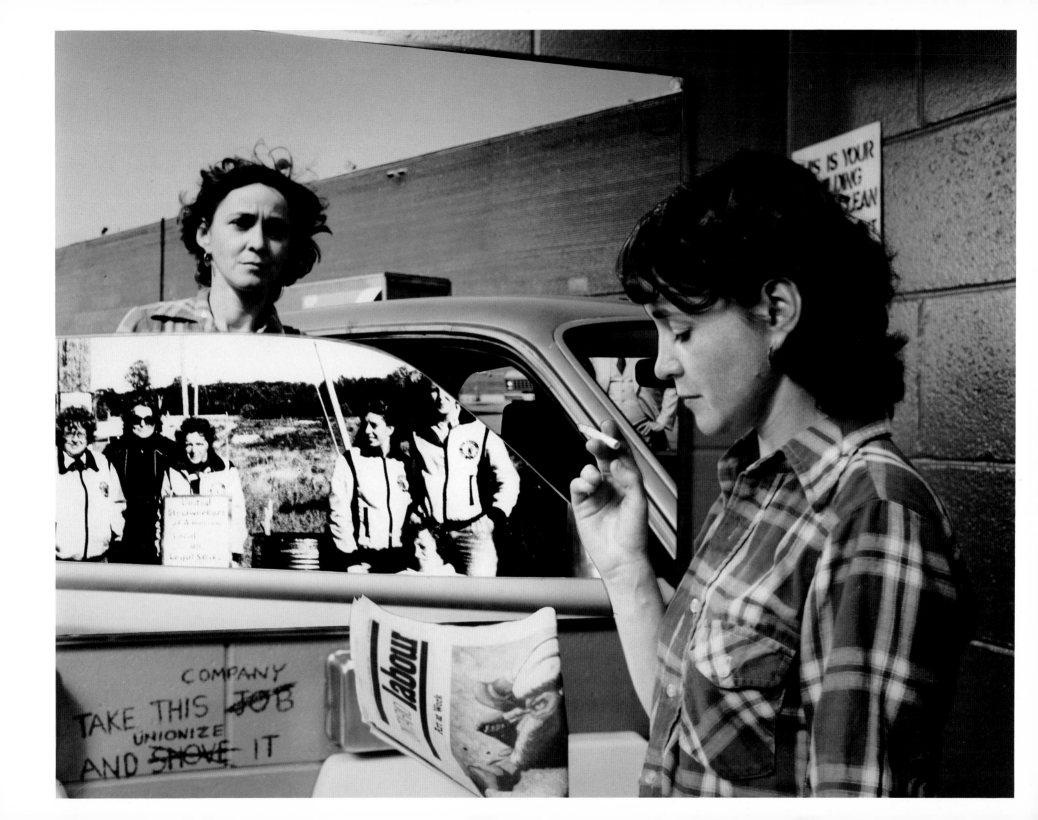

You know a strike can be a horrible experience but things happen that you'll never forget. My biggest thrill was the Women's Solidarity Day, near the end of the strike. Women came from all over, busloads of them, women we didn't even know cared about what was happening to us. But they did, and they all showed up.

We still talk about it. I'd never been involved in anything like that before and I couldn't believe the turn-out, all those women supporting us.

We realized that we were not the only ones who knew the problems women face when they stand up for their rights. We found out that lots of other working women know about what these situations do to their family and friends — the wounds they create. Wounds that have to be healed.

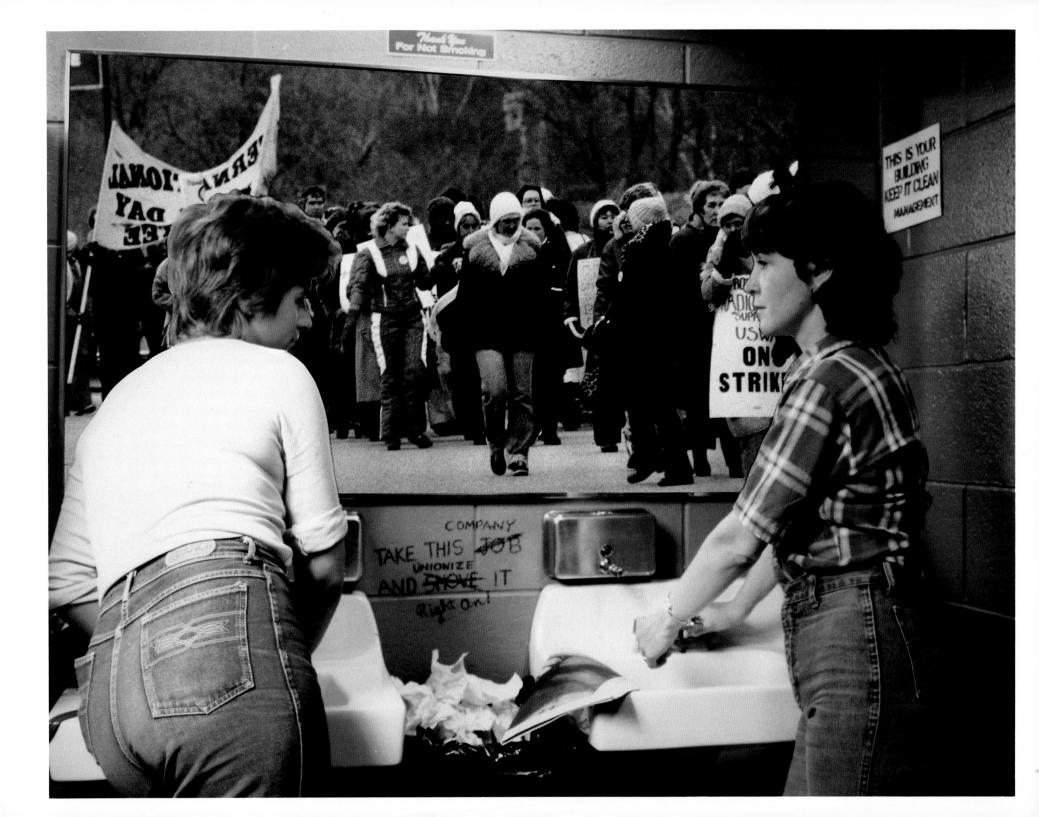

VICKY

Vicky worked in an isolated area, and word had it that the company was punishing her for her union activity. This was ironic: she was known as a responsible and hard-working shop steward.

She spent her isolation sticking labels on boxes of electronic equipment to be shipped all over the world. Her only companion was the printer that tapped out the labels. From a small computer in the order department, in a remote department in the warehouse, she learned the dot matrix geography of the electronics business.

The warehouse computers in Vicky's small town were linked to a world-wide system in the company's head office in Atlanta, Georgia. Inventory levels, sales volume, and production quotas were scrutinized and continually monitored from miles and miles away.

Atlanta breathed down her neck. She was always aware of a presence, a supervisor with no name and no face.

It's a year ago this Friday my father died. Mom phoned to ask if I'd come to see her, but I have mixed feelings about it. You see, I never got along with him. I felt like a stranger at his funeral. I couldn't even cry. That upset my mother.

My father always told me I'd never amount to anything. I grew up being told I was ugly and stupid. My father never hit me, he didn't have to. I was terrified of him. Afraid of what he might do. I still break into a sweat sometimes when I remember him

I used to be scared of management too.

I get my five-year pin from the company this Friday. Big deal. Five years with this company and I'm still only making $9,000 a year. Spent $80 for groceries, that'll last a week or two. $5.25 for coffee. I could cut down on that, I drink too much of it anyway. It's not good for my nerves.

Management's always telling us how good the company's doing. They own plants in Asia, shipping lines, trucks, and hundreds of stores. They even own a bank. They think we're all one big family. They like well-behaved children. You know the kind you see but don't hear?

They treat us as if we can't put two and two together. We don't even get the credit for organizing the union in here. They prefer to think we were manipulated by outsiders.

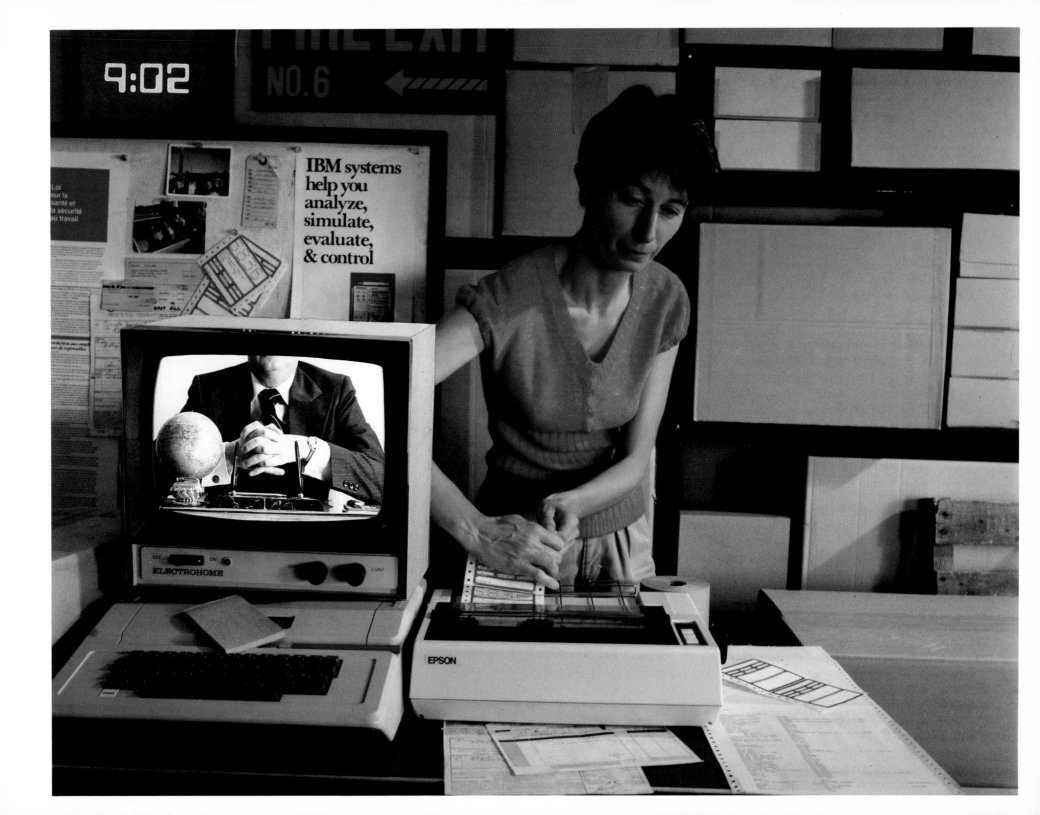

We got that union in here because we wanted it! We sweated blood to get that union.

You see, the invisible Atlanta head office people were willing to pay a million dollars to get rid of the union. To stop us from getting organized. What does that tell you? It tells me they had a lot to hide and a lot to lose. For one thing, they would have to start paying us a decent wage.

After the first union meeting, they fired five people within hours of each other. They knew Ray was an instigator — he was out for sure. The others were suspects. Ray was reinstated when the union laid charges. It's against the law to fire someone for organizing a union.

But the company gave Ray a lousy job and changed his hours. It's a common tactic, the same kind of thing they did to me. They don't miss a trick.

Another guy was reinstated but they shut down his department. Then they put his father, sixty years old and recovering from a heart attack, into a heavy lifting job. We all held our breath, terrified the old guy'd have another heart attack. Father and son both left. It wasn't worth it.

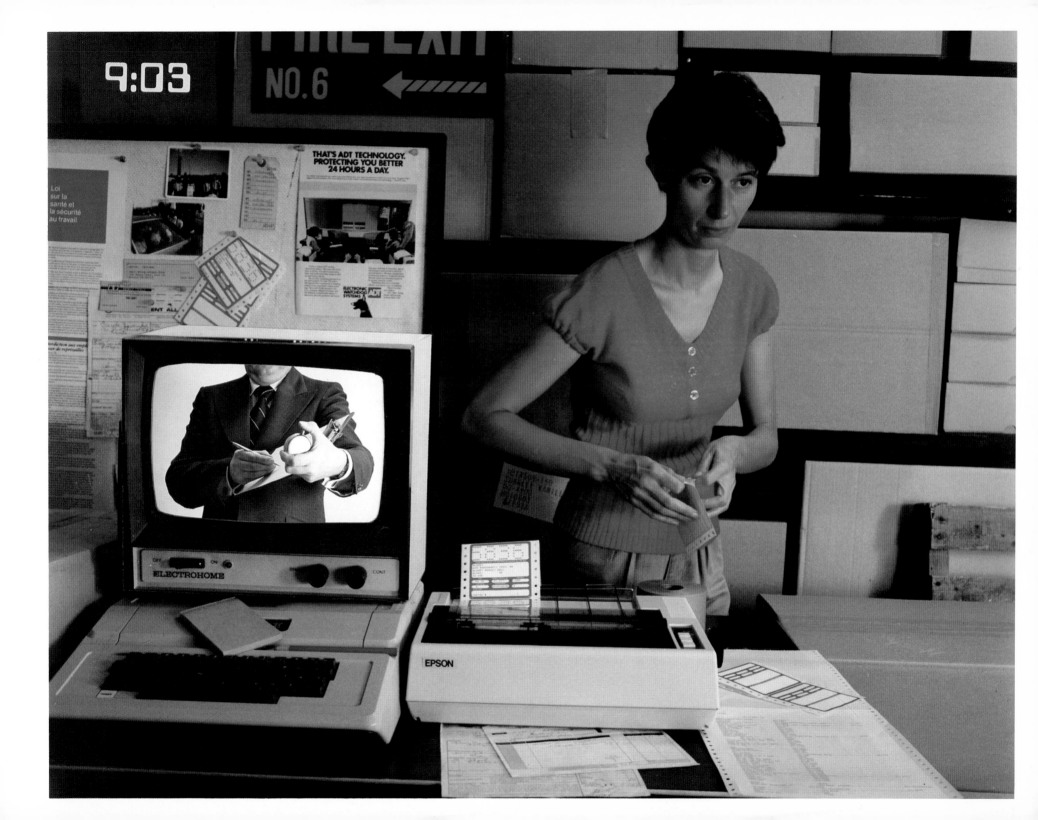

Fridays were the worst. Five minutes before quitting time you'd wait to see who'd got the axe. My friend May got it one Friday. I was right next to her. She'd been there longer than I had and needed that job every bit as much as I did. I didn't know what to say to her, I still had a job. My stomach just turned sour.

It was the same way I felt when Lynn went over to management's side. They bought her off. She'd been convinced she could change everything by joining management. She'd been one of our best union people, she could really talk. Everyone liked her. Then she became a foreman. I could have strangled her — my friend.

The company never let up. They even had T-shirts made up that said "I'm a company fink and proud of it."

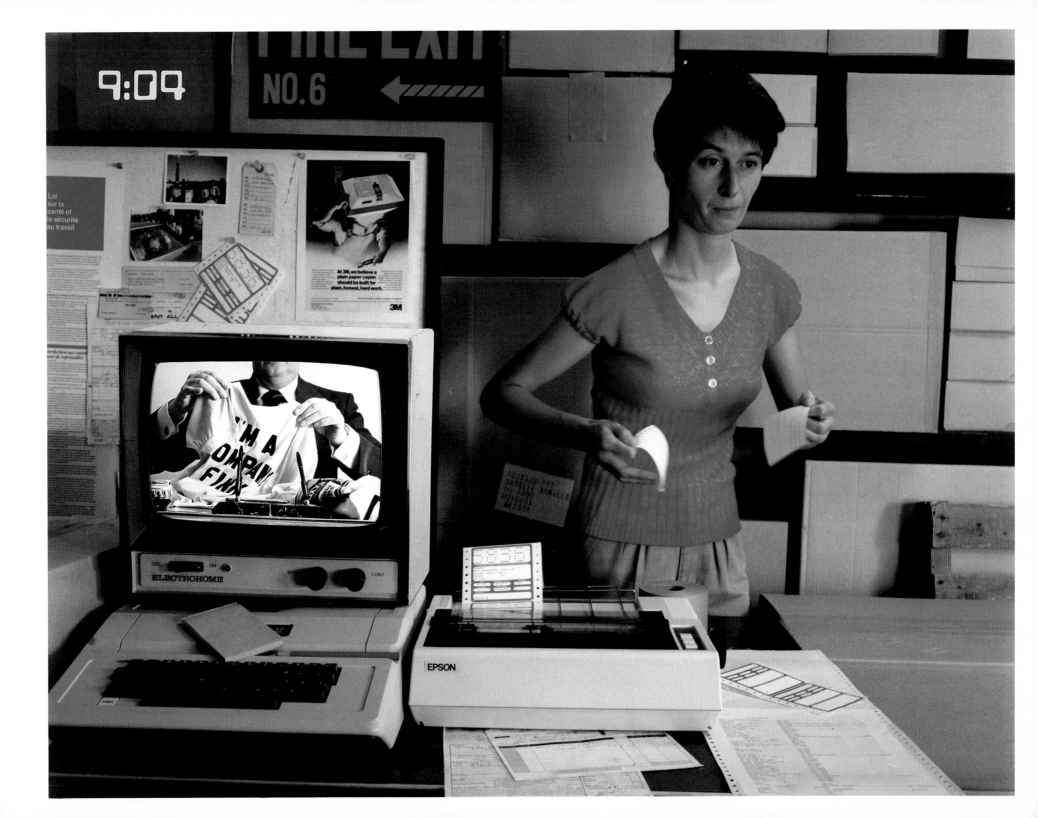

Intimidation was another one of their tricks. Long before the strike, Laura's house had burnt down. The company had taken up a collection for her. During the strike, some of us were sitting on the ground, off to one side, eating sandwiches. We weren't talking much. It was warm and we were enjoying the sun on our faces. We'd been watching a flock of geese glide north, right over our heads, right over the big company sign. After four straight days of rain, we were starting to remember summer.

Then I heard the sound of car tires on the gravel shoulder. I looked up to find one of the managers leaning out his car window. He was so close, we could feel the heat from his engine. He tossed a piece of paper at us. It was an old clipping from the company magazine, the one with the story about Laura's house fire. He was warning us. A week later the same nut set a union card on fire and tossed it at us.

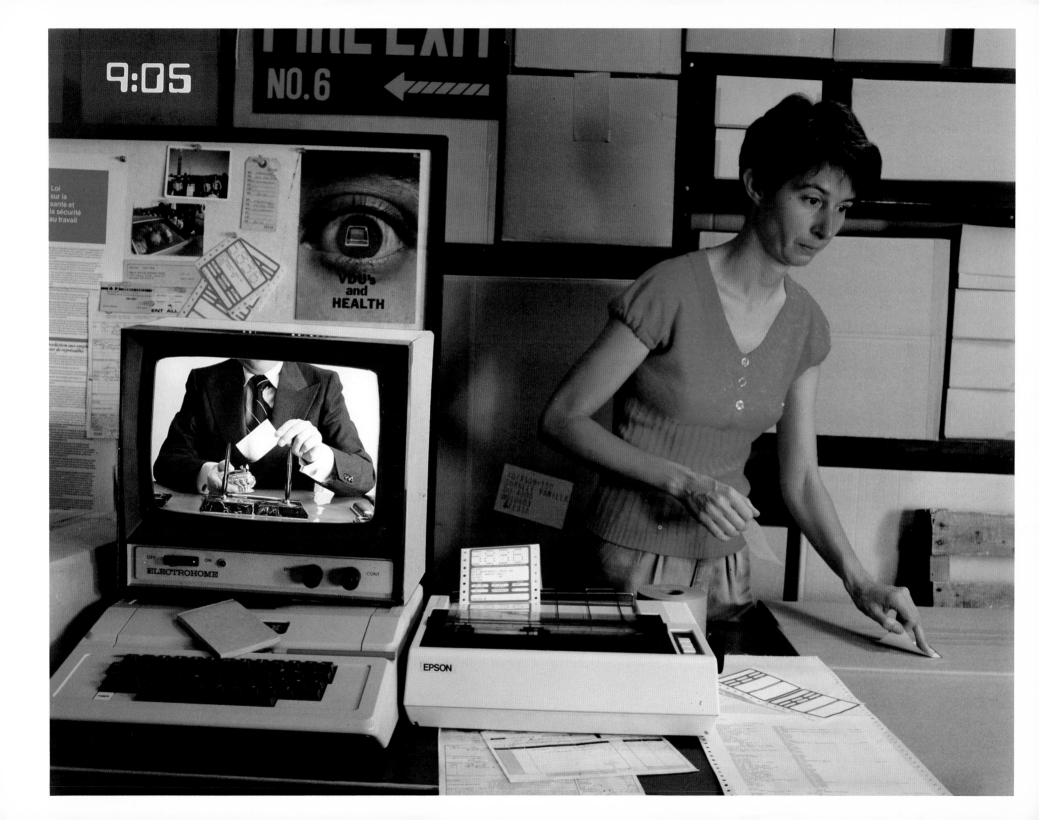

When we first charged the company with bargaining in bad faith — going through the motions of negotiating — we didn't expect to get much out of it. Maybe a public declaration that the company was a bunch of bastards, or something like that.

It took months of waiting for the decision. When we finally heard the Supreme Court award in our favour we all knew inside we were going to win. It went through me like a shiver. Right after that we all went to a union convention in Toronto. I had to get up and tell all the people we'd won in court. Everybody stood up and started clapping and cheering. I couldn't believe it. There must have been ten thousand people in that room and they were all cheering for us. I was crying and I caught Louise's eyes. She was crying too, we all were.

All the fear evaporated. Right then and there. I could only remember the sun and the day we had the picnic, on the side of the road, the day the geese came back.

We won.

THE MEETING

A year after the strike Jane phoned and asked the union members to meet her at a small restaurant near the warehouse. She told them she was concerned about rumours that the company was circulating a petition to have the union de-certified. But it was also an excuse to see the women again.

For two years, Jane had been part of their lives. As union organizer she had shared their fears and hopes. Since the strike she'd been out of town organizing other plants.

Seeing Jane again brought back many, not so old, memories, even though it seemed like years ago. The company made sure things were never dull. The de-certification petition was only the most recent crisis. Despite these intimidations, however, the union was slowly gaining support among the workers. The truck drivers had just joined.

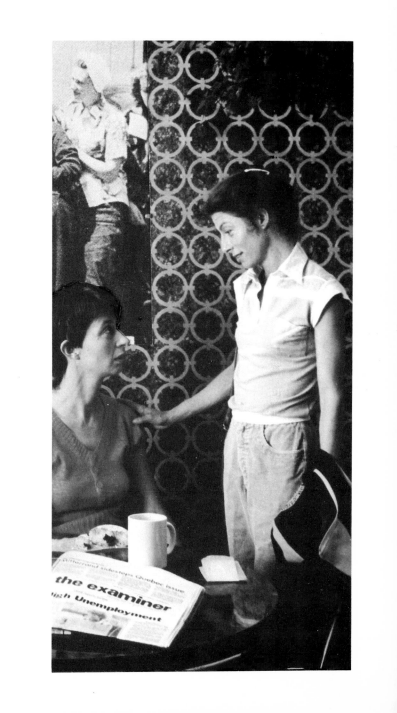

JANE

I love my work as a union organizer. But when I first hear about a new plant I am always overwhelmed by the size of the task. Research, phone calls, talking to new people, getting the picture straight. Teaching people what their rights are, helping them find the strength to stand up for themselves.

Every plant is different except for one thing. By the time I get there, the workers *know* they're being screwed. I never tell them it's easy because it's not. It takes a long time. And I never make promises. It's up to them.

It doesn't stop when you get your first contract either. You have to fight to hold on to everything you get. There's always the threat of de-certification, of taking it all away.

So you keep strong and you keep together. It's the only way I know to build a strong union movement. And I keep doing it because it's worth it.

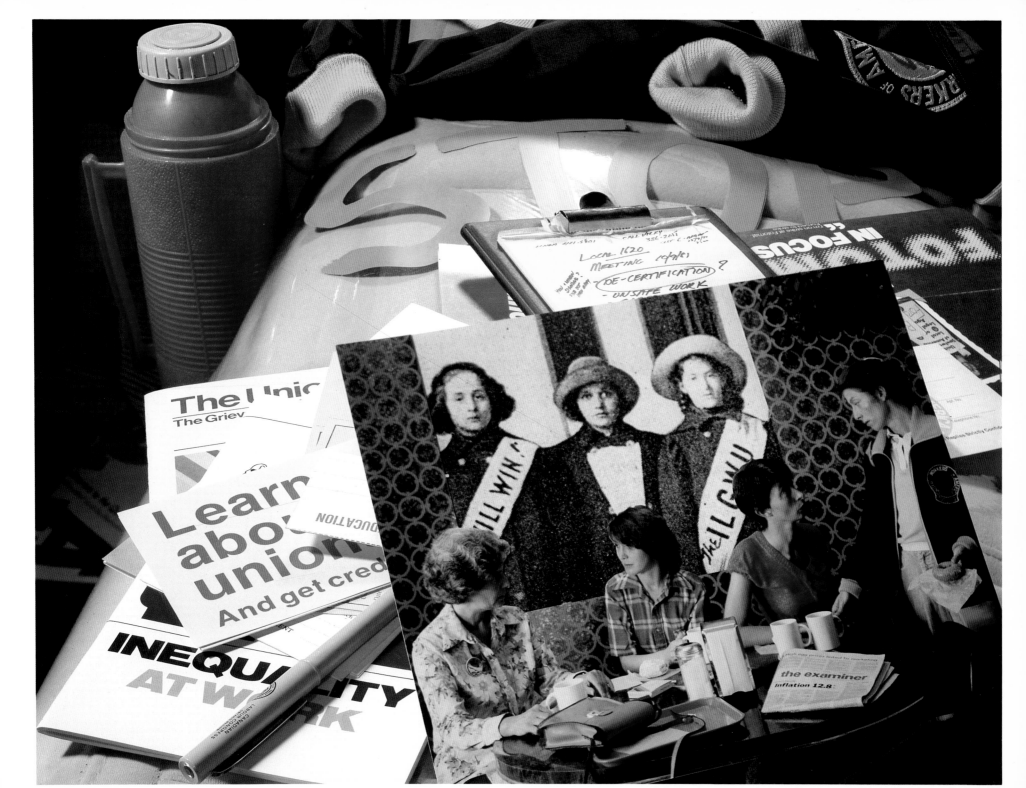

NATALIA

I used to think work and pleasure didn't mix. You work through the day and that's it. You go home and live another life.

Before the union I didn't go anywhere without Ed and the kids. Most women never think of it. You just go out with your family or your husband's friends. Right? I mean, we still have those same friends, but I look forward to being on my own with the girls sometimes now. We've been through a lot together.

I think Ed understands. We've both changed a lot in the last while. He's learned to respect and love me the way I always wanted.

One night, during the strike, he made a confession and I'll never forget it. He'd been sort of irritated about me always rushing off to the union meetings and the picket line. But instead of giving me a hard time he turned to me and said quietly, "I'm glad it's you out there, because I don't think I could handle it."

I was proud of him for admitting it. I was proud of myself.

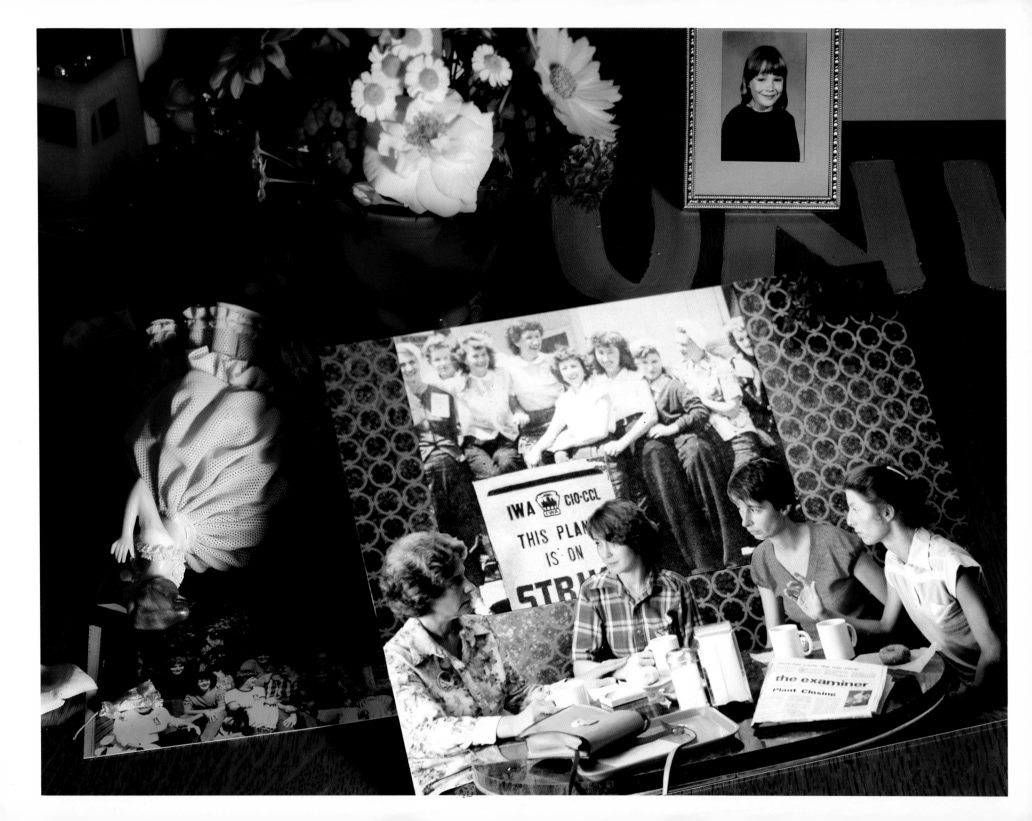

LINDA

Jim's latest plan is to go to Alberta, he says there's money out there. I just plain told him I don't want to go. The strike hurt my marriage. The more he complains about me or my union activity, the more I react against him. There just doesn't seem to be a way out.

The guys at work tease him. They say his wife's a radical. I'd like to tell them I'm underpaid and underprivileged, if that's what they call a radical.

Before the strike none of us knew what was going to happen. It turned into one heck of a battle. But we became stronger, by standing up for our rights for a change. And we did it by sticking together. It was like finding a family — a family of women.

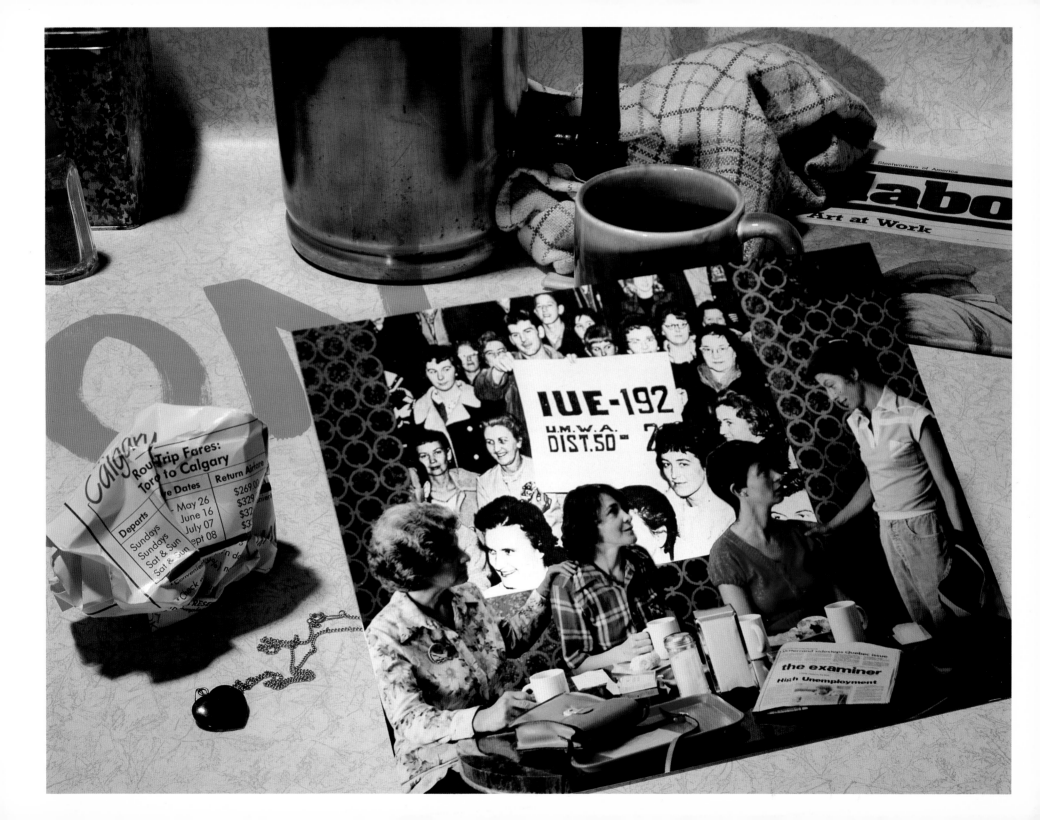

VICKY

It's a good thing I didn't do everything my father told me. If I had, I would have made some big mistakes. He was fiercely anti-union.

Remember Al? They let the poor guy go after he drove a truck twelve years for the company. Turns out he knew my father. They played cards together or something. Seems just before my father died he told Al he was really proud of me out there on the line. The old man didn't think I had it in me.

Father hated unions so much I didn't think he'd even give me a thought. Too bad the poor old bastard couldn't have come up to me and said it to my face. It would have made a difference.

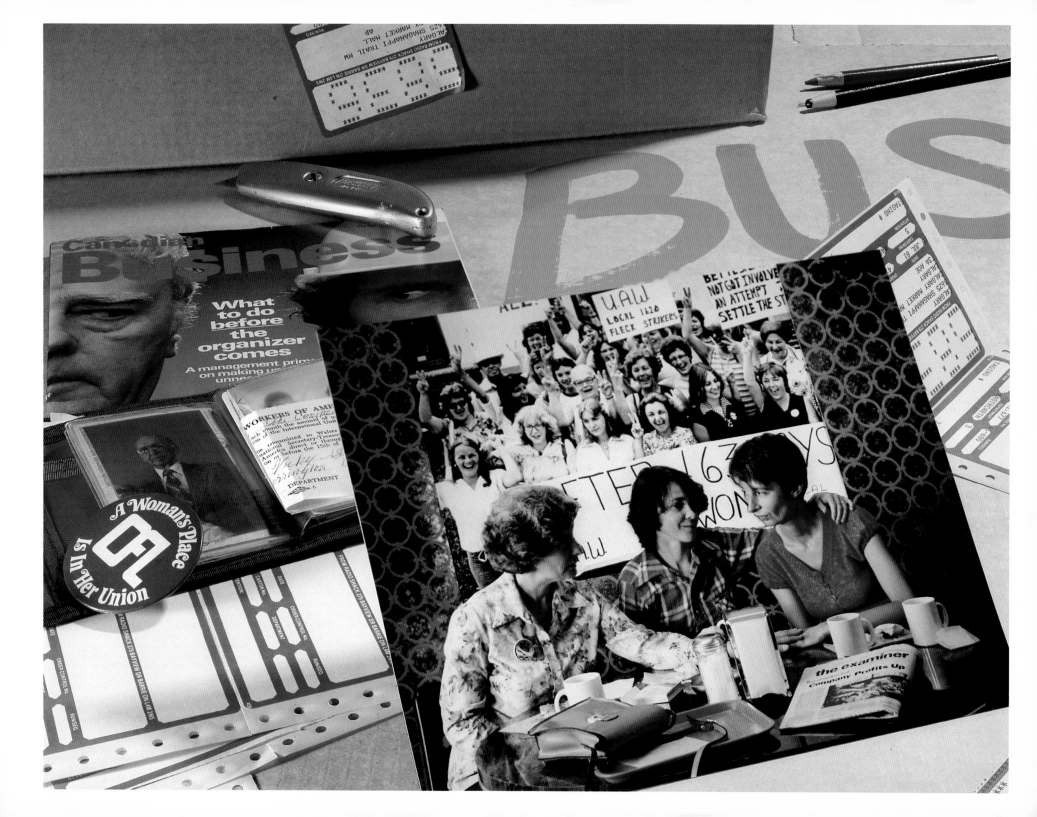

VICKY

Got a call from Martha the other night. The one who was against the union for a long time. She was all excited.

They'd done something to her at work. So she told the foreman off. "I'll go and file a grievance and I'll win the bugger," she said.

She told me she wasn't used to standing up for herself. In her whole life she had never stood up and talked back. She's just like the rest of us when we started, back before the union. She said the next time it'll be easier.

Easier? Maybe. A bunch of women against a huge corporation. Money's still more important to them than people. You keep hoping things will change for the better. If not for us, then for our children.

FOUR YEARS LATER

After the first strike the company was real good to us for a while. We actually got along with management. They had to clean up their image, you see. Sales had really dropped because of the boycott, and it had hurt them. Then, suddenly, they turned right around and made it so bad we had to strike again.

They made an offer that took the time limits out of the grievance procedure. Without that, you've got no contract, no way to argue and fight. They knew we wouldn't accept it.

The current labour legislation is a big joke, you know. You have the right to organize, the right to collective bargaining, and the right to strike. But the company has the right to bring in scabs to take our jobs if we exercise our rights. It's the simplest loophole in the book, the easiest way to break a union — and it's all legal.

Our experience taught us a lot. The way things are, companies are allowed to withdraw offers once they have been put on the bargaining table. Companies can dismiss striking workers while they are on a legal picket line. Companies can hire scabs.

When somebody takes your job, it's hard to remain cool, calm, and collected. But we must stick together. For one thing, we need anti-strikebreaking laws — and we need them now.

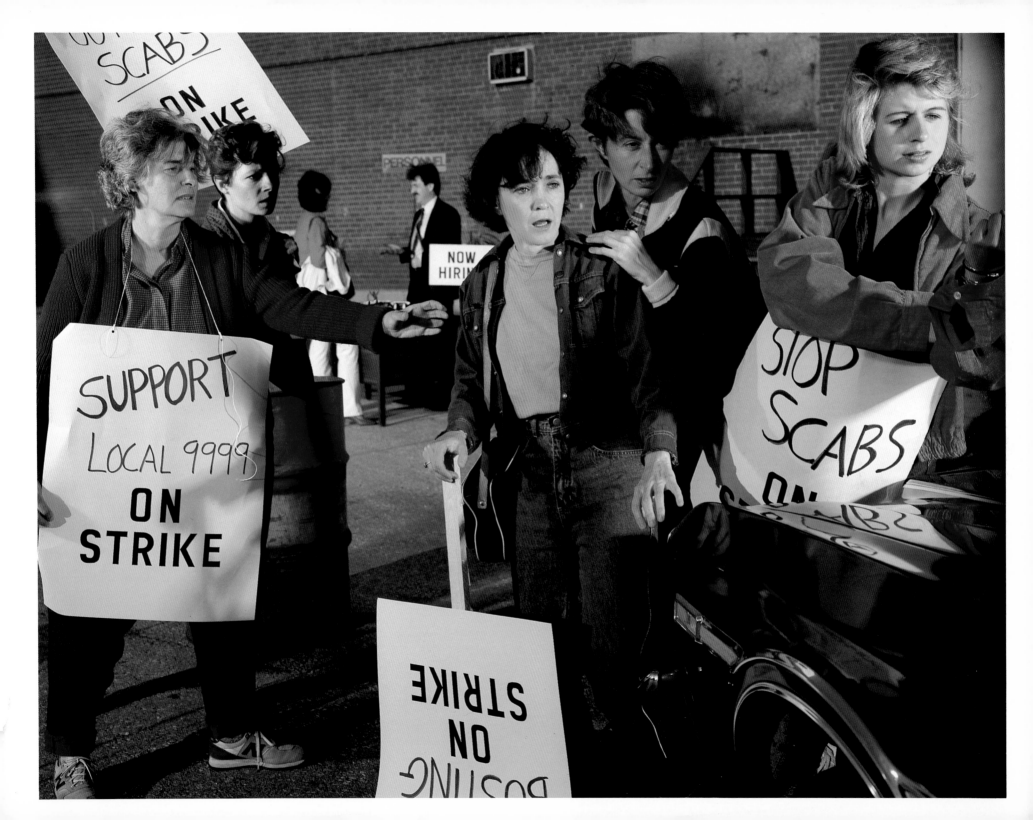

CHRONOLOGY

Women's First Contract Strikes in Ontario

United Autoworkers of America (UAW) Local 1622 on strike against Fleck Manufacturing. Centralia, Mar. 6, 1978, to Aug. 15, 1978. 75 women out; 30 crossed the picket lines and stayed in. *Issue:* Union recognition. *Demands:* Rand Formula, better working conditions and pay increase to $3.50 an hour. *Outcome:* they won — Fleck negotiated. Contract included Rand Formula, base wage to $3.25, time to move from base to top reduced from 10 to 2 years.

There was a lot of intervention from police throughout the strike: 7,000 police days logged; police bill totalled $2 million. Strong support from UAW, other unions, and the women's movement.

United Steelworkers of America on strike against Radio Shack. Aug. 9, 1979, to Mar. 29, 1980. 200 employees, 85% women. *Major issue:* first contract. The union had been certified in October 1978 but Radio Shack refused to bargain. On Dec. 5, 1979, the Ontario Labour Relations Board charged Radio Shack with unfair labour practices. *Outcome:* Radio Shack signed a contract on Mar. 29, 1980.

This was the first Radio Shack in North America to be unionized. The workers now have their second contract; male drivers are included. Women's solidarity picket on Nov. 8, 1979.

Second strike for a third contract, 1985. Again the company hired scabs and tried to hold out against the union. Eventually the union accepted the company's final offer, but the company refused to honour it, and many strikers were not hired back. The cases remain pending before the labour board.

United Autoworkers of America (UAW) on strike against Blue Cross, private insurance agency. September 1979. 200 clerical workers. *Issue:* on strike for union recognition and first contract.

The union was left waiting for several years for a decision from the Ontario Labour Relations Board. In 1981 scabs formed an "employees' association." The OLRB decision, when finally reached, went against the union and it was de-certified.

United Steelworkers of America on strike against Fotomat. Oct. 22, 1979 to Jan. 1981. 100 employees, 99% women. *Major issue:* first contract. *Outcome:* they won a contract.

A May 1981 Ontario Labour Relations Board decision forced Fotomat to reinstate workers it had fired during the strike.

United Food and Commercial Workers Union on strike against Maple Lodge Farms, the largest poultry plant in Ontario. Sept. 15, 1980, to Oct. 12, 1980. Over 500 employees, of whom 280 to 300 went on strike. 50% women. *Issue:* first contract and voluntary overtime. Many incidents with police on picket line. *Outcome:* they got a contract.

United Steelworkers of America on strike against Irwin Toys. Toronto, June 1981 to Jan. 1982. 114 employees out, 80% women. *Issue:* first contract. *Demands:* wage increase to $4 an hour (most employees were earning minimum wage or less) and sick benefits. *Outcome:* settlement, after a bargaining-in-bad-faith decision by the Ontario Labour Relations Board, in the union's favour.

During the strike there were many incidents on the picket line involving police. A national boycott was organized. The strike received wide public attention, with strong support from the women's movement. Women's Solidarity Day was held, Oct. 9, 1981.

After the strike the company continued anti-union activity. Only 42 of the 114 striking employees were called back and many of those were at the lowest wage level. Eventually the union was de-certified.

Retail, Wholesale and Department Store union on strike against Eaton's Department Store. Six locations in Toronto, Brampton, London, and St. Catharines, Nov. 30, 1984 to May 7, 1985. Approximately 1,000 employees out, 80% women. *Issue:* first contract. *Demands:* wages, benefits, seniority, overtime and grievance procedures, job security. *Outcome:* settlement with few gains other than the contract itself. Included management rights clauses, continuous service instead of seniority, and grievance procedures on employees' own time.

The settlement was controversial. The union was under pressure to accept the contract because the employees would lose legal right to their jobs after being out for six months. Massive support for the strike was mobilized through the union and women's movements. The union organized a successful boycott. A women's solidarity picket was held, Dec. 1, 1984. International Women's Day march travelled through Eaton's main store at Yonge and Dundas streets in Toronto on Mar. 9, 1985. A large benefit concert was held at Massey Hall, May 6, 1985.

Since the strike, Eaton's has made attempts to de-certify the union.

Union of Bank Employees on strike against the Canadian Imperial Bank of Commerce. Known as the "Visa strike". Toronto, June 12, 1985 to Feb. 7, 1986. 230 Visa Centre employees went out. Fifty mail unit employees went out on Sept. 18, 1985. 80% were women. *Issues:* union recognition and a first contract. *Demands:* wage increase, better work hours, grievance procedures, job security, contracting out protection, and seniority. *Outcome:* a settlement was imposed by the Canada Labour Relations Board, giving union recognition, a 5% wage increase, grievance procedures, contracting out protection, and seniority rights.

The union considered the settlement to be an important victory. The strike was the first major attempt to organize the banking sector, with the exception of a few small branches. It received wide support from the Canadian Labour Congress (which paid out $300 a week to each worker for strike pay), the UAW, various other unions, and the women's movement. The union implemented a variety of tactics to disrupt the bank's services: tying up phone lines, organizing "bank-ins", etc.

On May 2, 1986, the Stationary unit ratified an identical contract, and the union continued to plan for a major organizing drive to sign up the other units.